NAPTIME WITH JOEY

LAURA IZUMIKAWA

G

Gallery Books

New York London Toronto Sydney New Delhi

G

Gallery Books
An Imprint of Simon & Schuster, Inc.
1230 Avenue of the Americas
New York, NY 10020

First Gallery Books hardcover edition October 2017

GALLERY BOOKS and colophon are registered trademarks of Simon & Schuster, Inc.

For information about special discounts for bulk purchases, please contact Simon & Schuster Special Sales at 1-866-506-1949 or business@simonandschuster.com.

The Simon & Schuster Speakers Bureau can bring authors to your live event. For more information or to book an event, contact the Simon & Schuster Speakers Bureau at 1-866-248-3049 or visit our website at www.simonspeakers.com.

Interior design by Davina Mock-Maniscalco
Lettering by Eunice Park—euniepark.com

Manufactured in China

10 9 8 7 6 5 4 3 2 1

Library of Congress Control Number: 2017943745

ISBN 978-1-5011-7406-3
ISBN 978-1-5011-7407-0 (ebook)

TO MY JO-CHAN.

YOU ABSOLUTELY CHANGED MY LIFE.

THERE AREN'T ENOUGH
WORDS AND KISSES [AND COSTUMES]
TO SHOW YOU HOW MUCH

I LOVE YOU,

MY DUMPLING.

AND FOR ALLEN.

MY HEART IS FULL OF YOU

AND I AM YOURS

FOREVER.

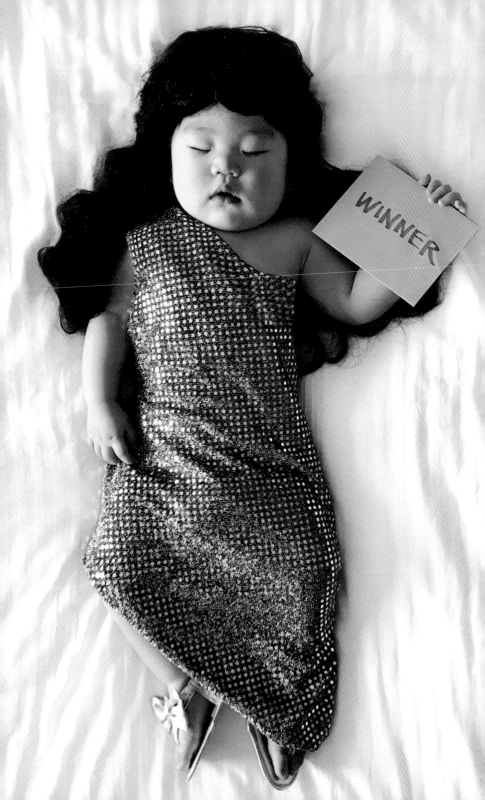

AND
THE OSCAR FOR
BEST NAPPER
GOES TO...

ZZZZZZ.

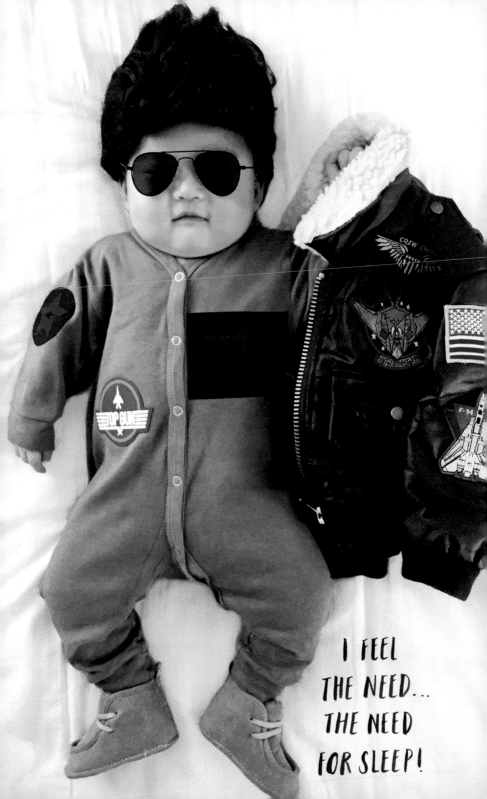

I FEEL
THE NEED...
THE NEED
FOR SLEEP!

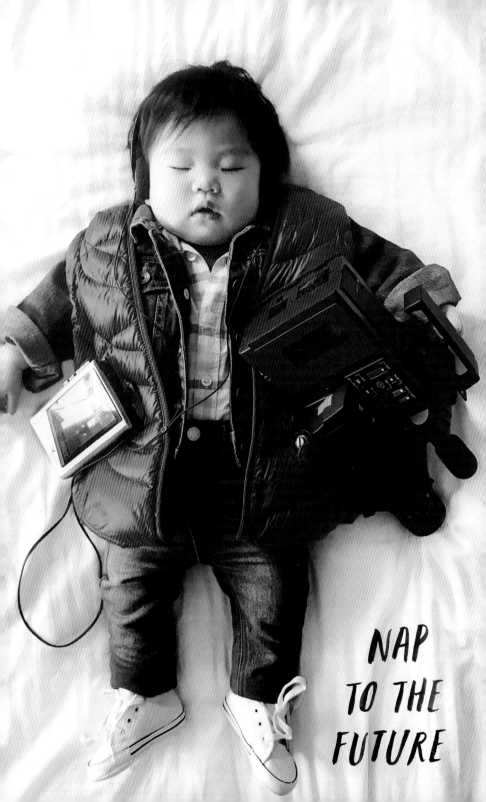

NAP
TO THE
FUTURE

CATCHING
FLIES
WHILE
CATCHING
ZZZS

MAKING
THE
JUNK
DRAWER
FUN AGAIN

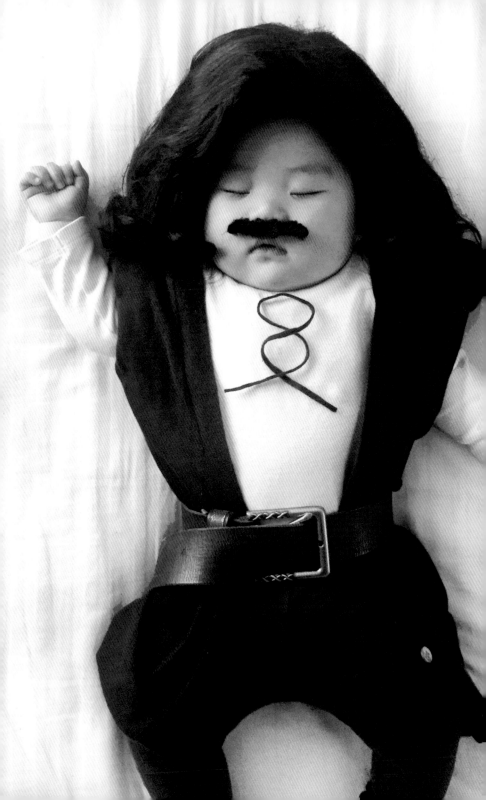

HELLO.
MY NAME
IS INIGO
MONTOYA.
YOU KILLED
MY FATHER.

PREPARE
TO CHANGE
MY DIAPER.

JOEY, YOU GOT SOME 'SPLAININ' TO DO!

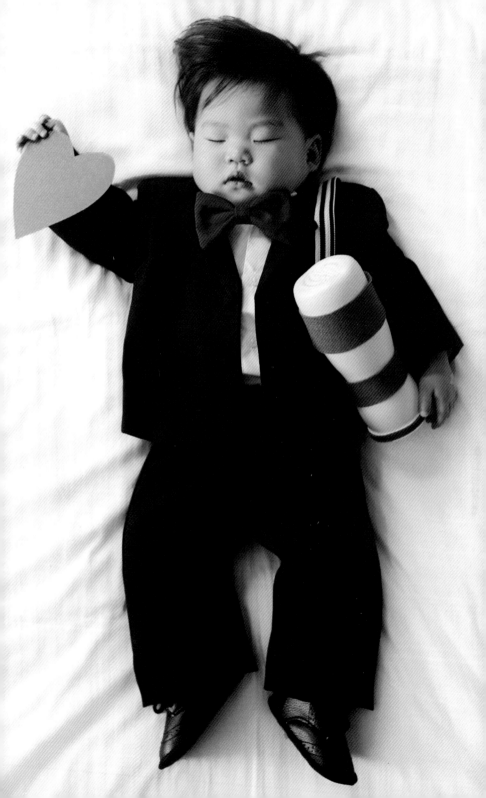

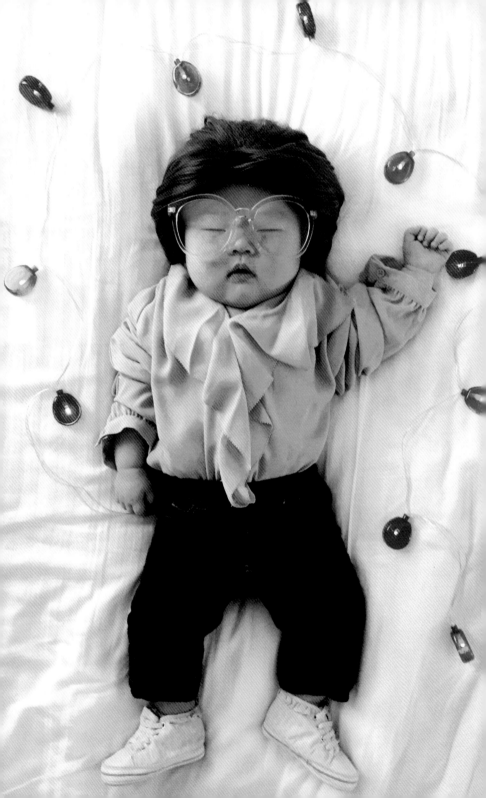

#JUSTICEFORBARB

#JUSTICEFORBARB

#JUSTICEFORBARB

#JUSTICEFORBARB

#JUSTICEFORBARB

#JUSTICEFORBARB

#JUSTICEFORBARB

#JUSTICEFORBARB

#JUSTICEFORBARB

#JUSTICEFORBARB

#JUSTICEFORBARB

ON A SCALE OF 1 TO 10, HOW TIRED ARE YOU?

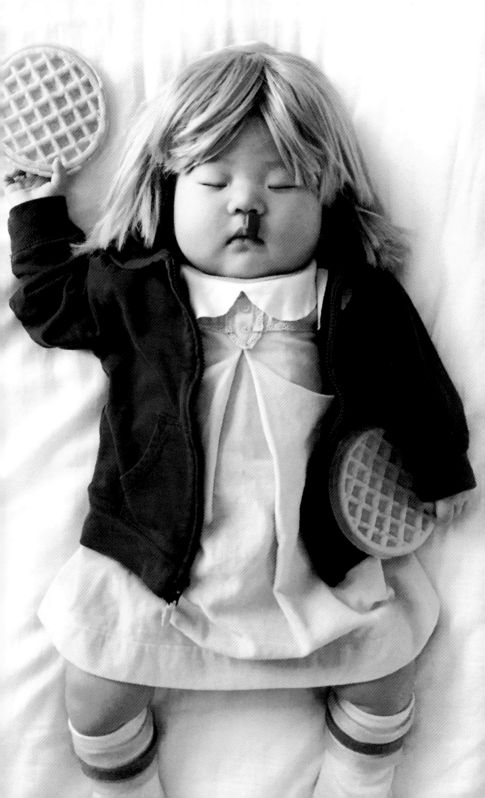

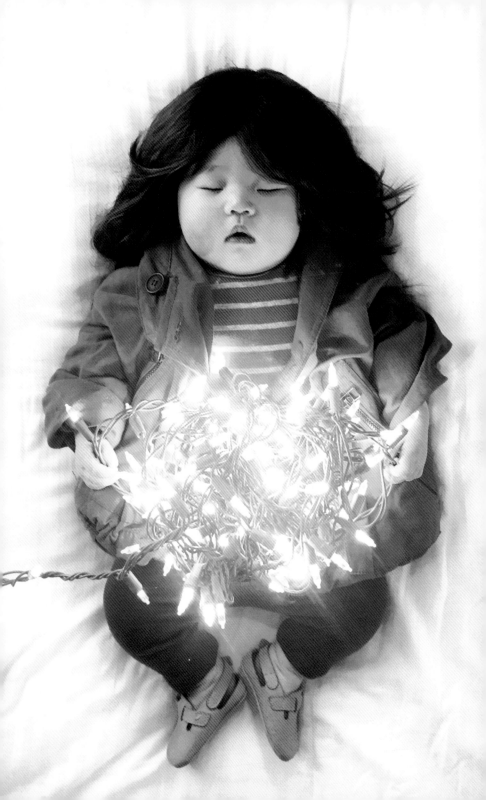

MAYBE I AM A MESS.
MAYBE I'M CRAZY.
MAYBE I'M OUT OF MY MIND!
BUT GOD HELP ME,
I WILL KEEP THESE
LIGHTS UP UNTIL
THE DAY I WAKE UP
FROM THIS NAP.

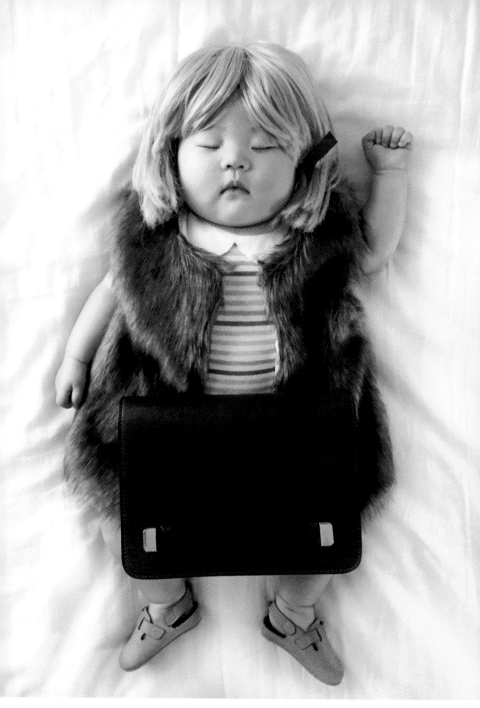

SHE WAS KNOWN FOR HER
EXTREME NARCOLEPSY.

16

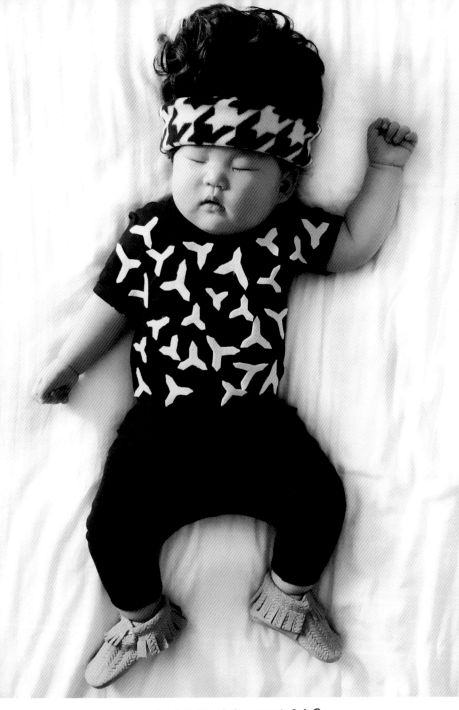

WHAT IS THIS!?
A CENTER FOR NAPS!?

17

SUNDAY, MONDAY,
NAPPY DAYS!
TUESDAY, WEDNESDAY,
NAPPY DAYS!

NAPPIN'
ALL WEEK
WITH YOU!

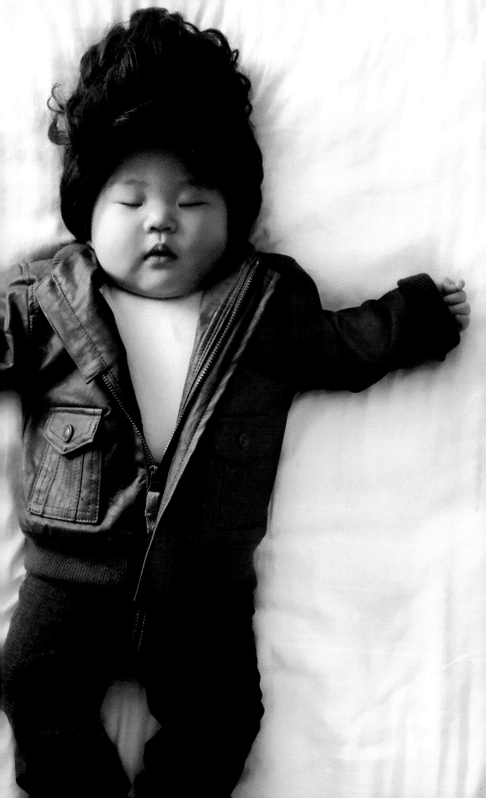

GET THAT BABY CORN **OUTTA** MY FACE!

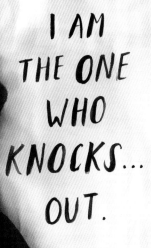

I AM THE ONE WHO KNOCKS... OUT.

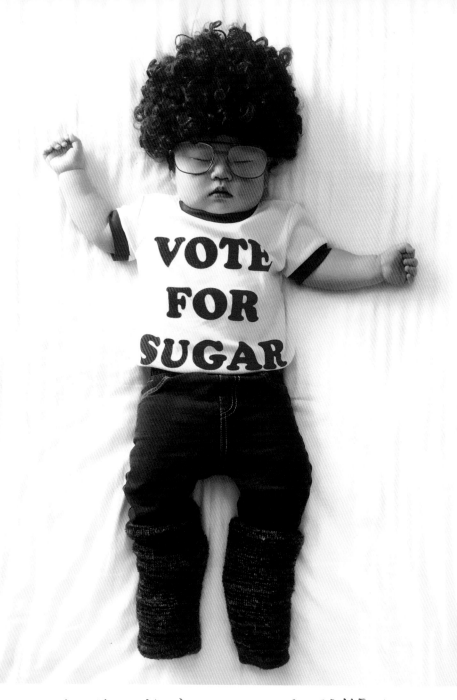

I THINK I'M GONNA TAKE A NAP-OLEON.

WHO YOU GONNA CALL?
DOZE-BUSTERS!!

BEARS.
BEETS.
BABYSTAR
GALACTICA.

CHILL BILL

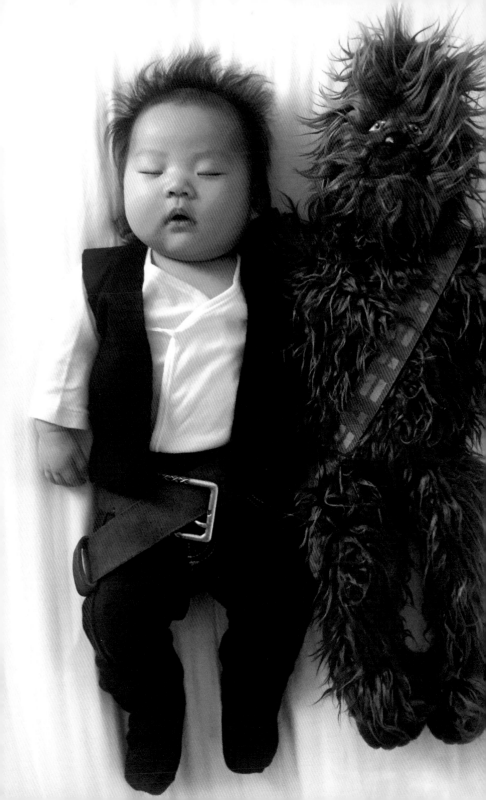

WHEN THINGS GET A LITTLE HAIRY, DON'T GO SOLO.

HEY, I JUST MET YOU,
AND THIS IS CRAZY.
BUT I'M YOUR FATHER,
SO JOIN ME MAYBE.

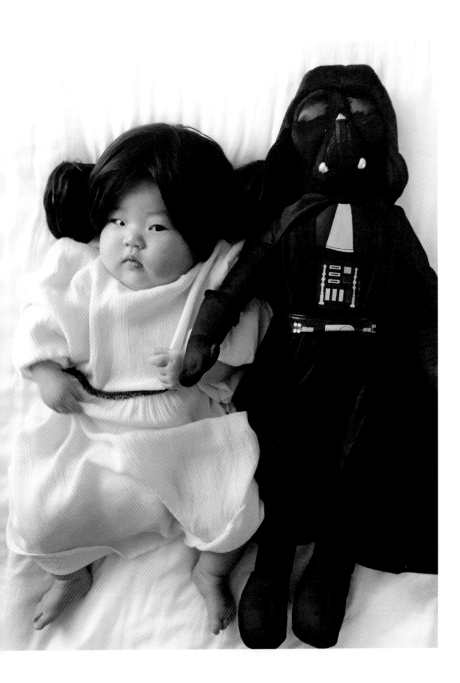

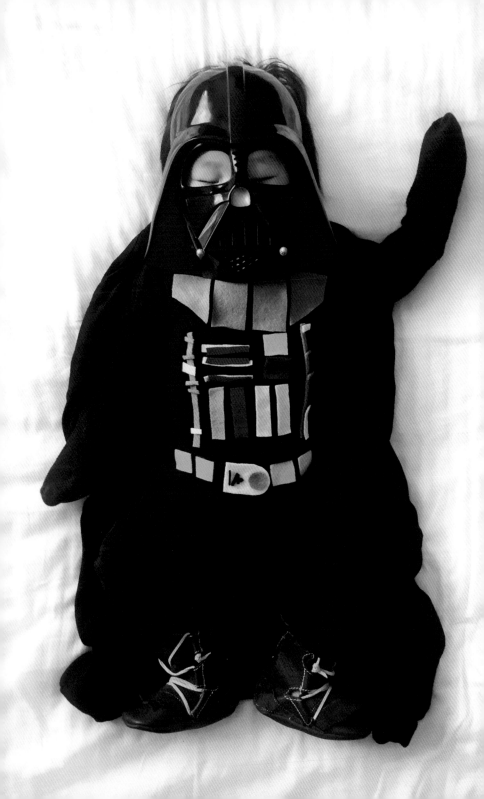

HOW COME DARTH VADER
TOOK THE STAIRS?

HE COULDN'T FIND
THE ELEVADER.
HE WAS LOOKING FOR IT
IN ALDERAAN PLACES.

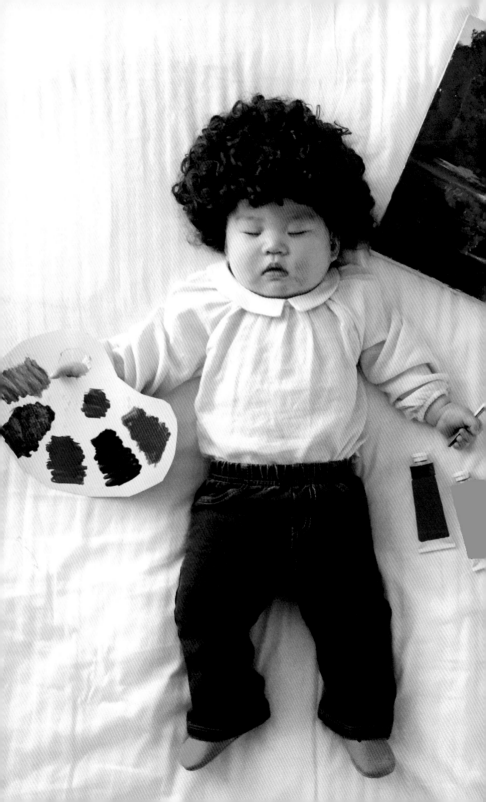

WHAT DOES
A PAINTER DO
WHEN HE GETS
COLD?

HE PUTS ON
ANOTHER
COAT.

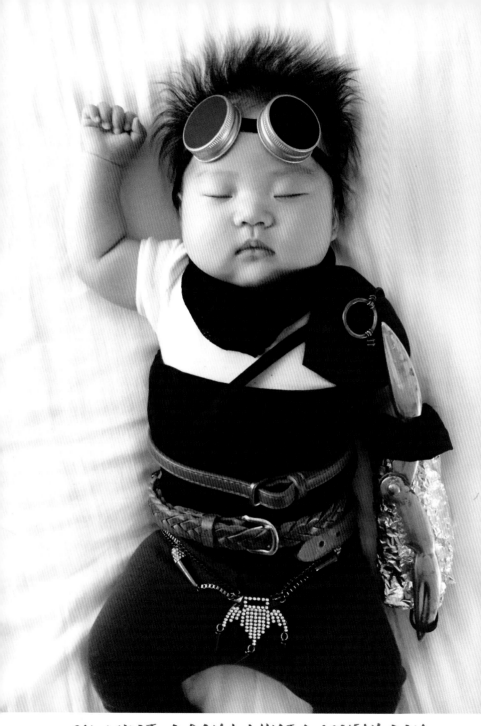

OH, WHAT A DAY! WHAT A LOVELY DAY FOR A NAP!!

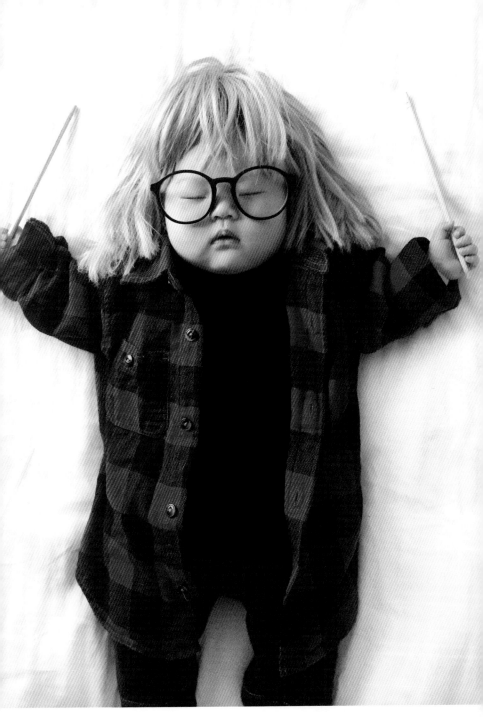

PARTY ON, GARTH.

35

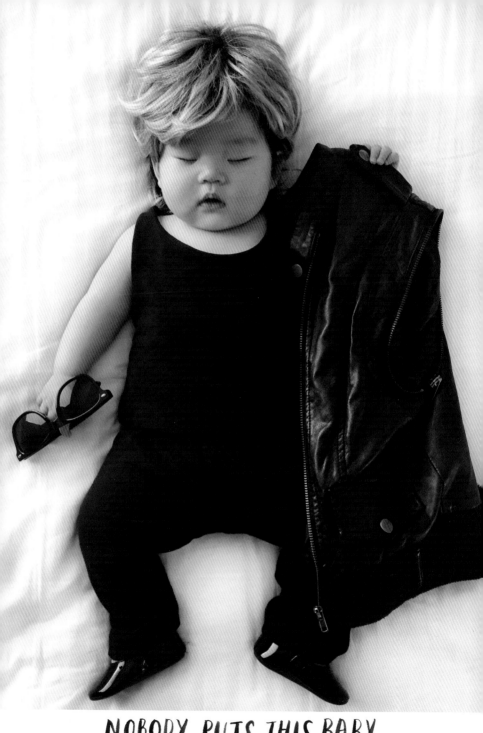

NOBODY PUTS THIS BABY
IN THE CORNER.

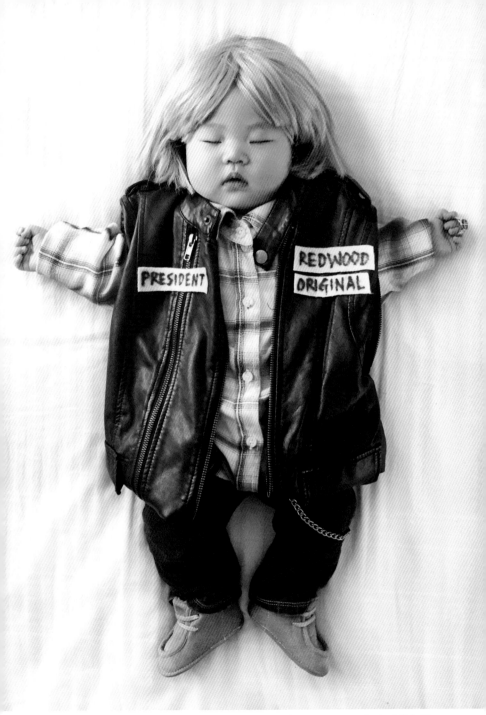

I TRIED TO START MY MOTORCYCLE
BUT I WAS JUST TWO-TIRED.

37

JOINED THE NIGHT'S WATCH.
I HAVE NO YGRITTES.

THE HILLS ARE ALIVE WITH THE SOUND OF SNORING.

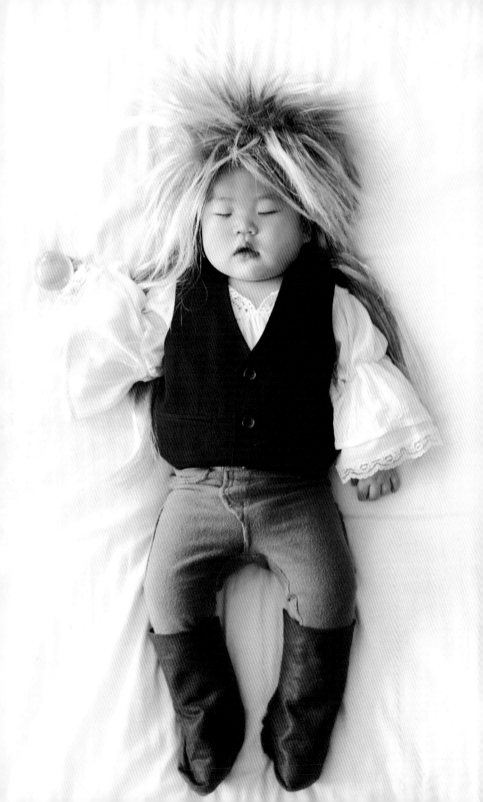

YOU REMIND ME
OF THE BABE.

WHAT BABE?

BABE WITH
THE POWER NAP.

HAPPY KITTY, SLEEPY KITTY,
PURR PURR PURR.

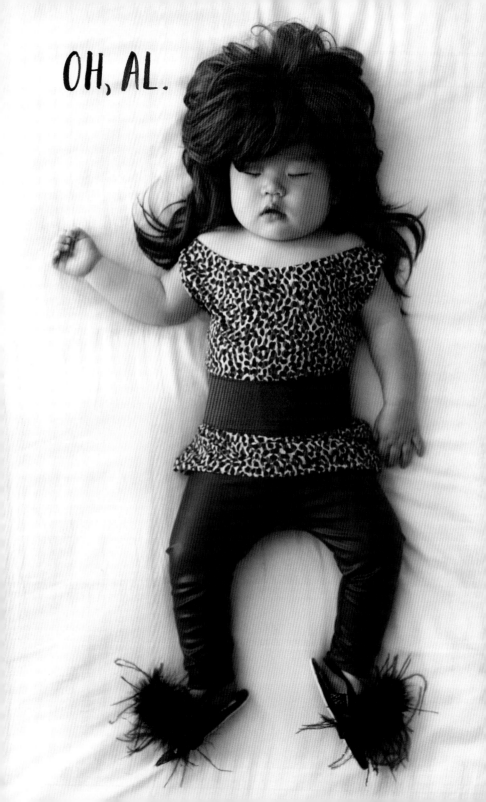

OH, AL.

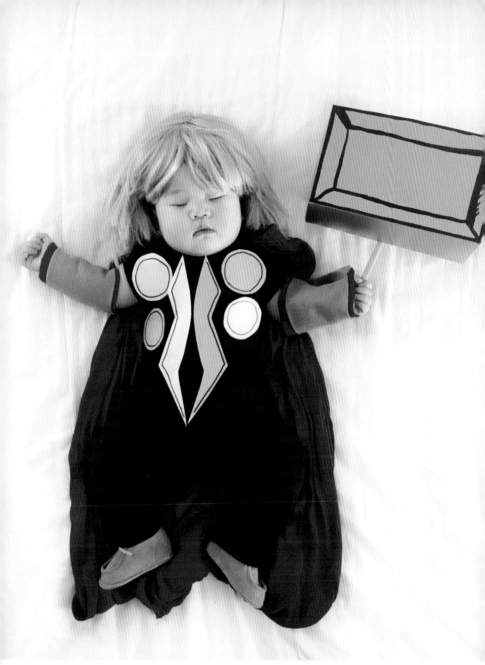

I AM SO THOR FROM CARRYING THIS HAMMER.

I AM
BABY GROOT.

WHY DID THE NINJA
GET CAUGHT
SLEEPING?

SHE DIDN'T WEAR
HER SNEAKERS.

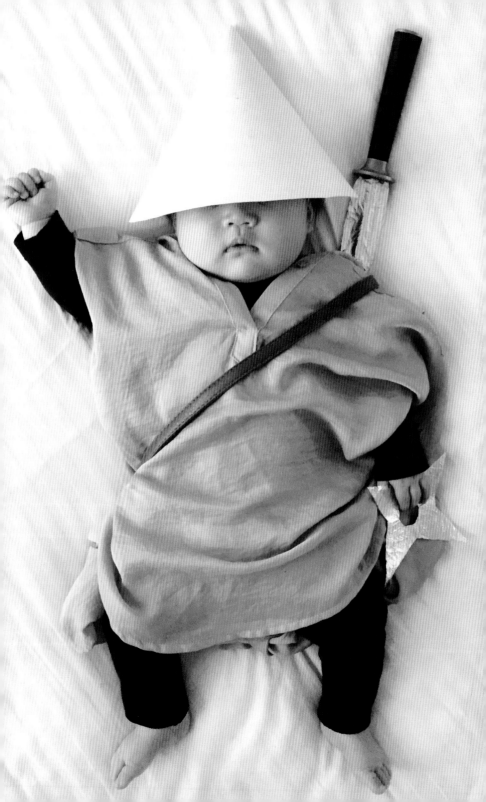

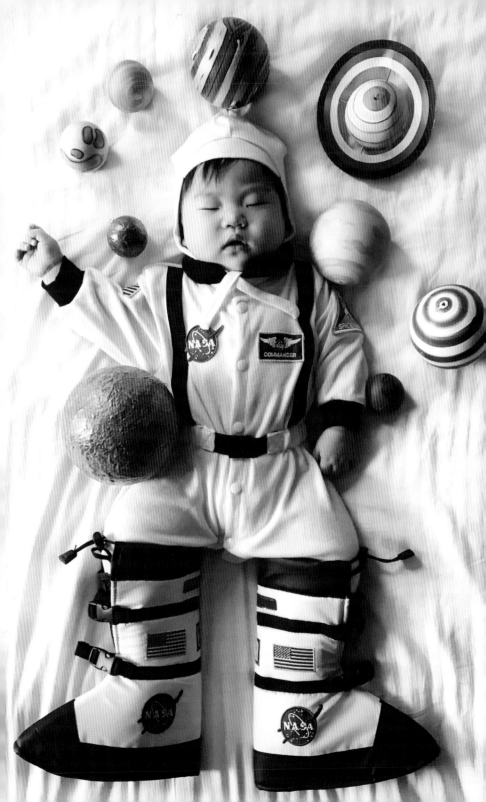

HOW DO YOU PUT A BABY ASTRONAUT TO SLEEP?

YOU ROCKET.

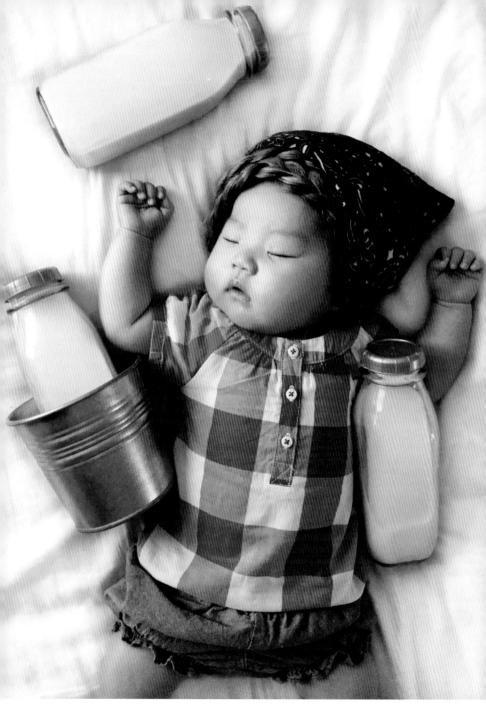

MY MILKMAID BRINGS ALL
THE BOYS TO THE YARD.

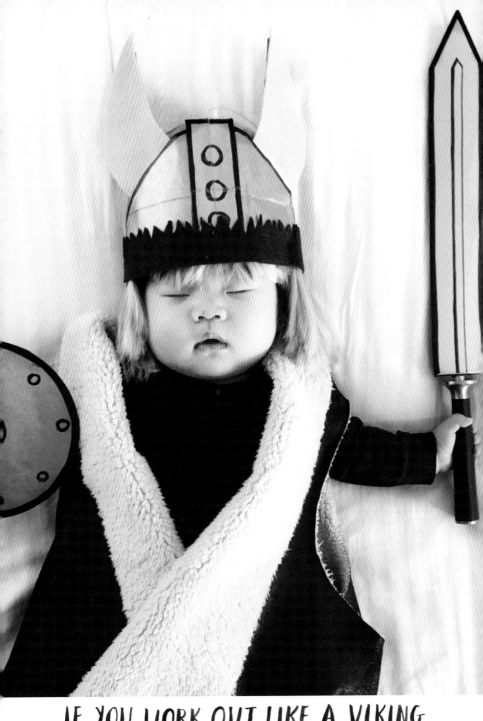

IF YOU WORK OUT LIKE A VIKING
YOU'LL BE THOR IN THE MORNING.

51

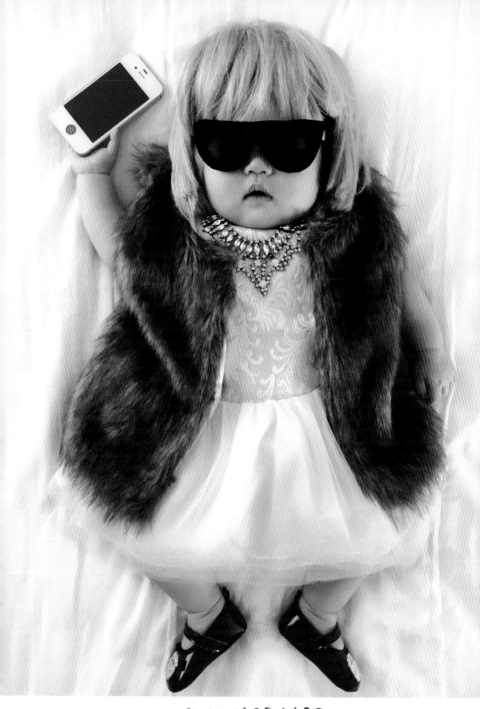

THIS NAP WAS
APPROVED BY ANNA.

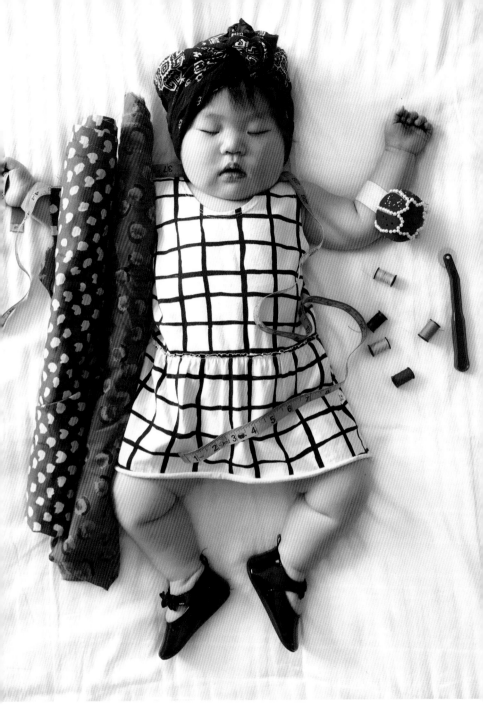

I'M SEW EXHAUSTED. I WOULD'VE STAYED
AWAKE BUT I RAN OUT OF SEAM.

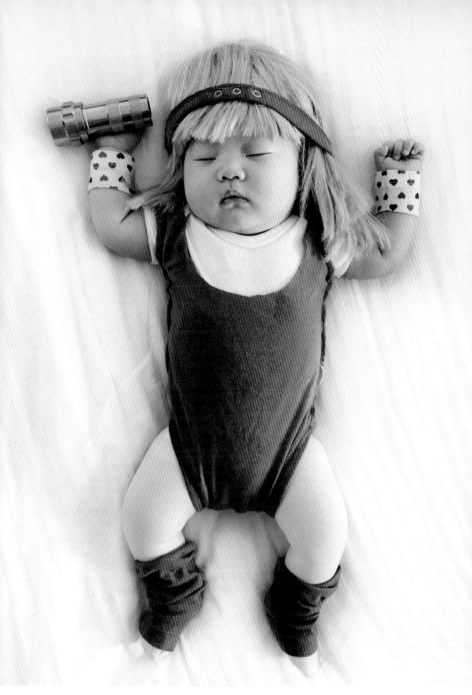

OH MY QUAD.
BECKY, LOOK AT HER BUTT.

WHAT FILM DID THE WRENCHES STAR IN? REMEMBER THE TIGHTENS.

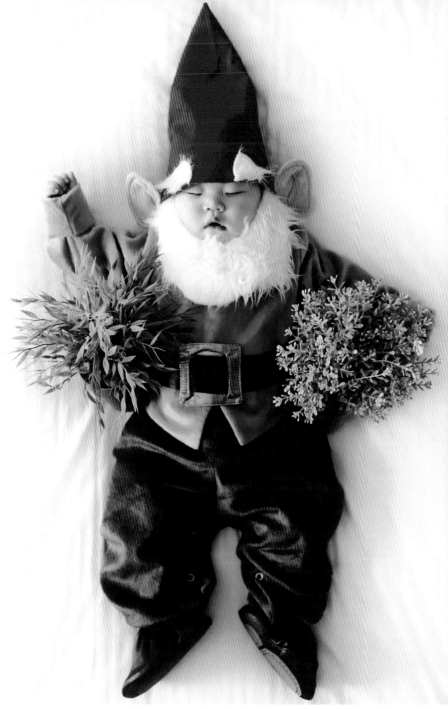

I'M PRETTY DOWN TO EARTH.
YOU GNOME SAYIN'?

#WIZARDCRUSH WEDNESDAYS

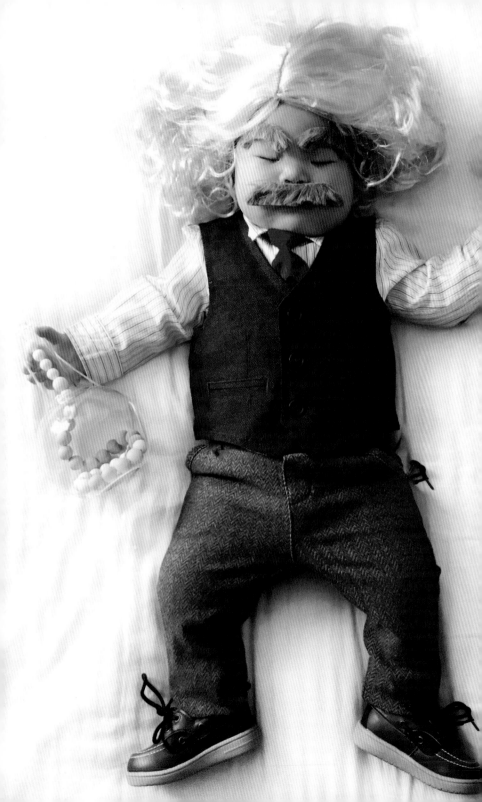

WHAT'S
FASTER
THAN
THE SPEED
OF LIGHT?

ME
FALLING
ASLEEP.

WHAT DO YOU
CALL A NAPPING
WOODSMAN?

A SLUMBERJACK.

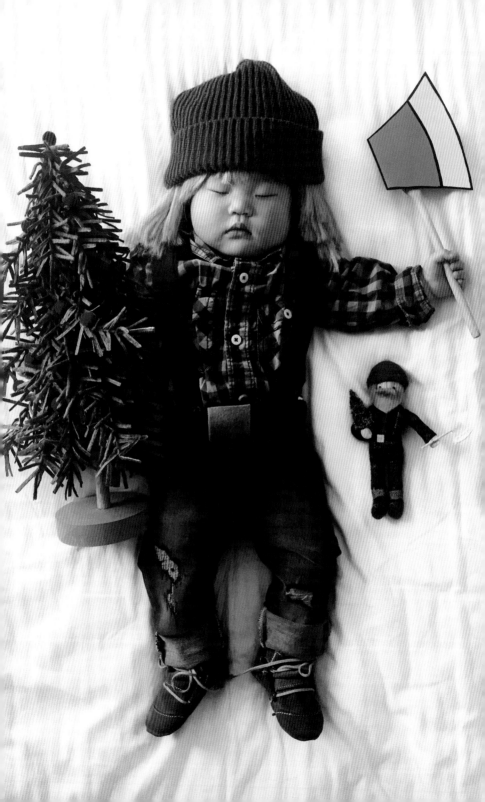

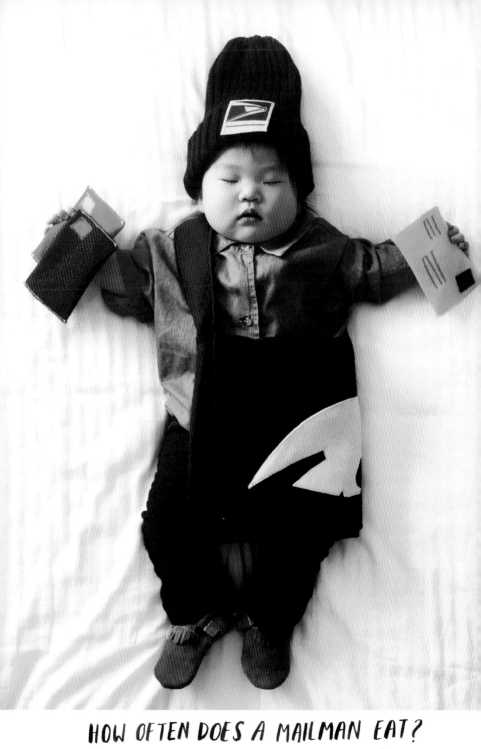

HOW OFTEN DOES A MAILMAN EAT?
HE EATS THREE MAILS A DAY.

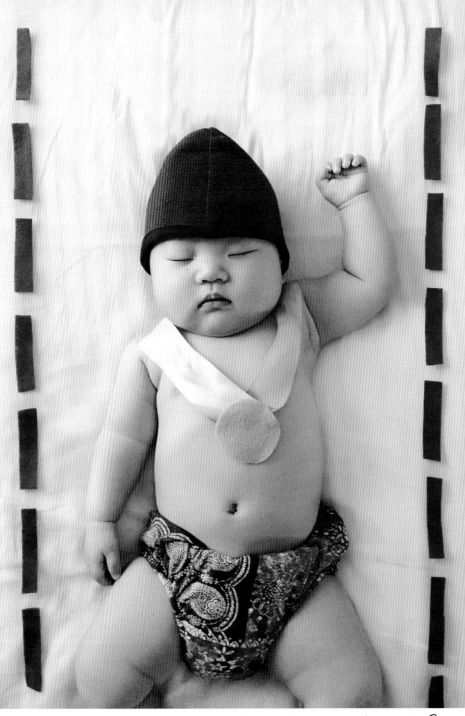

WHAT'S THE BEST EXERCISE FOR A SWIMMER?
POOL-UPS.

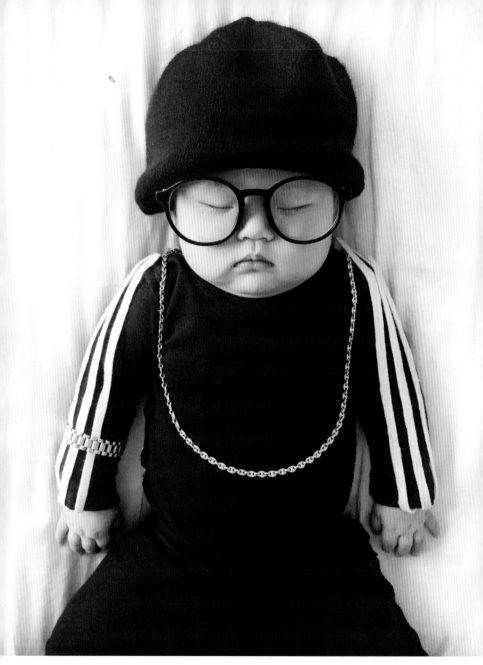

IT'S TRICKY TO NAP ON TIME,
TO NAP ON TIME THAT'S RIGHT
ON TIME, IT'S TRICKAAAY!!

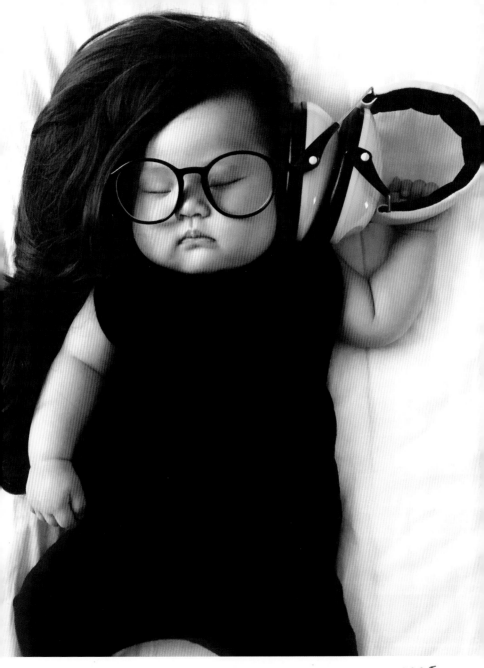

MY DJ NAME WOULD BE DJ ENZYME
CUZ I'M ALWAYS BREAKING
IT DOWN.

SIA IN
MY
DREAMS.

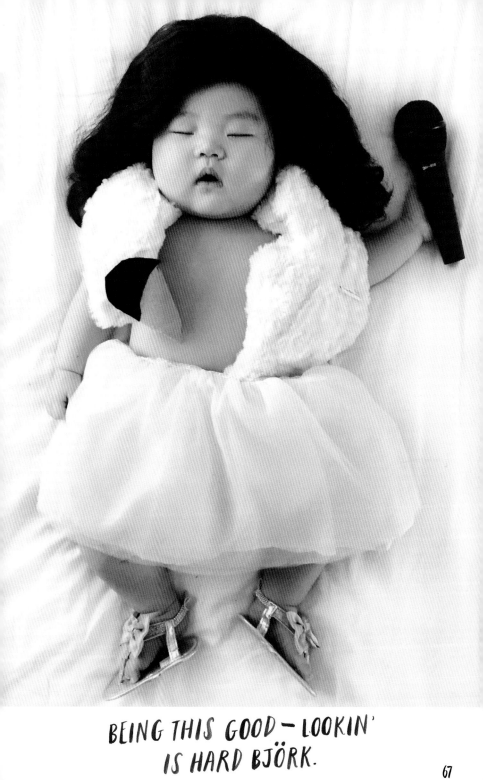

BEING THIS GOOD — LOOKIN'
IS HARD BJÖRK.

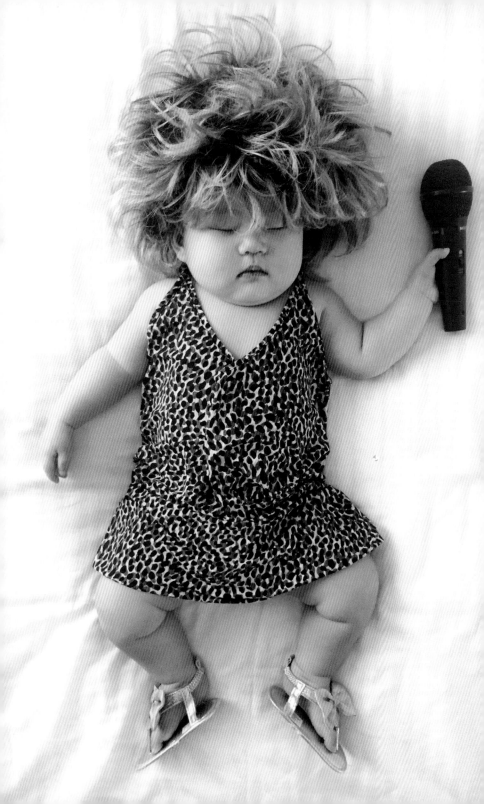

YOU'RE SIMPLY THE BEST. BETTER THAN ALL THE REST I CAN GET.

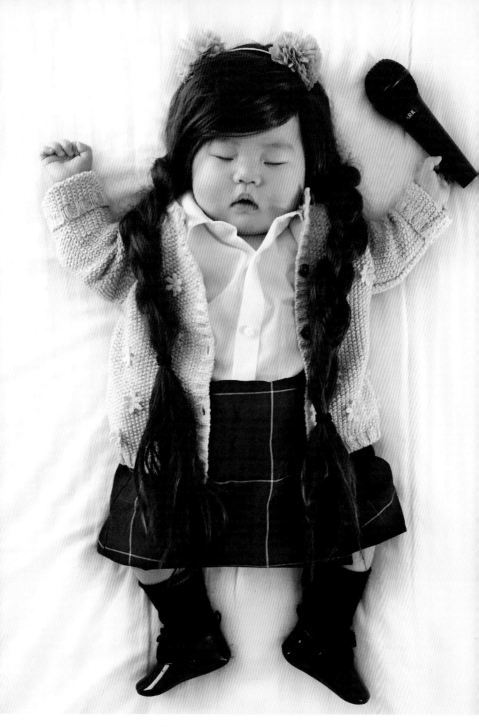

OH BABY BABY

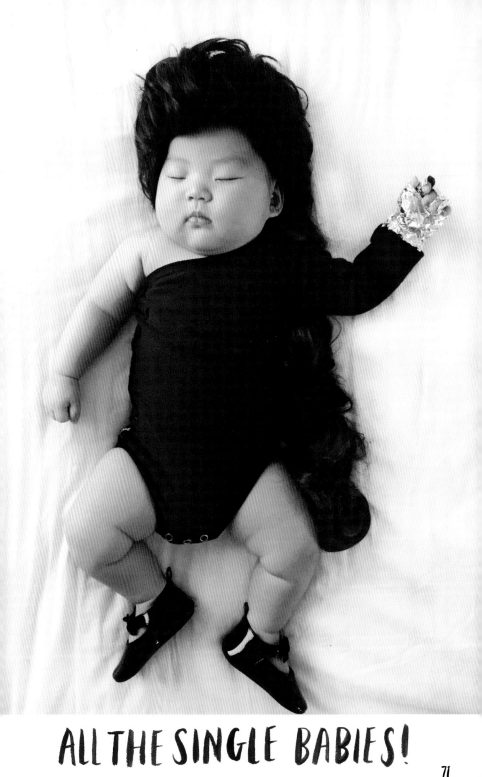

ALL THE SINGLE BABIES!

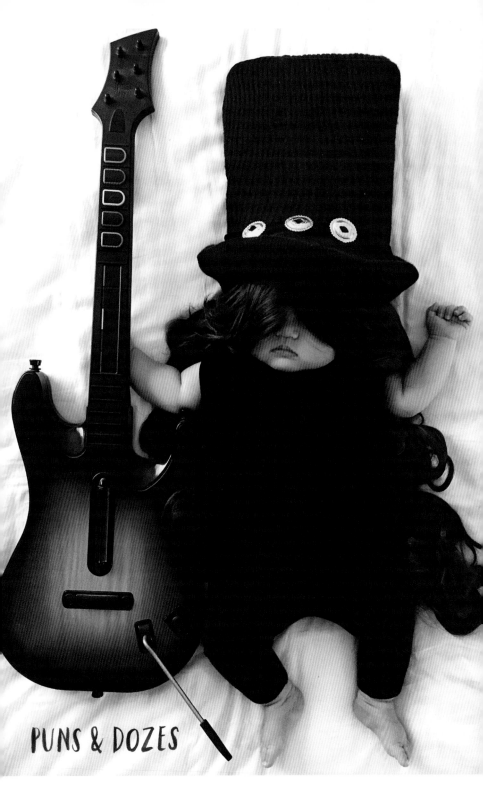

PUNS & DOZES

I'M SCENTIMENTAL ABOUT YOU.

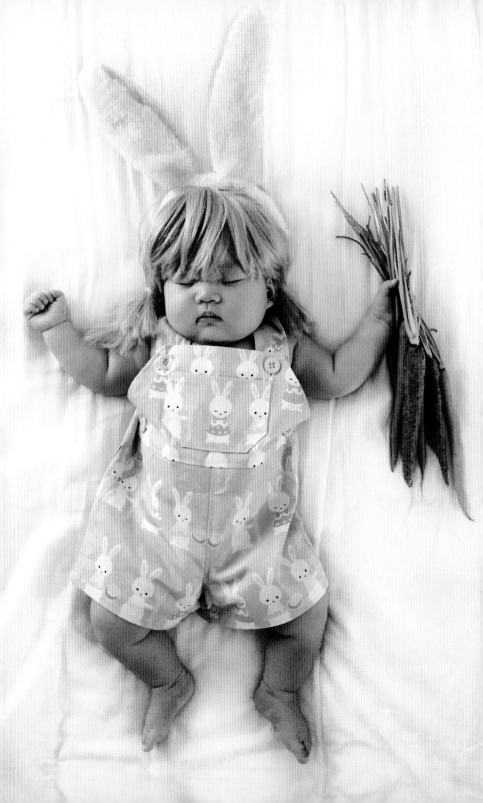

IT'S BEEN
SO HOT HERE.
THANK GOD
WE HAVE
HARE
CONDITIONING.

I'VE NEVER SEEN A BUTTERFLY CRY, BUT I HAVE SEEN A MOTH BAWL.

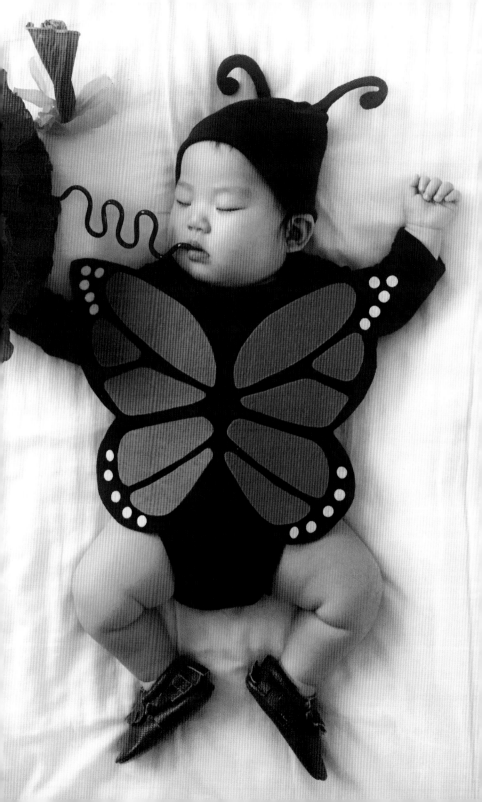

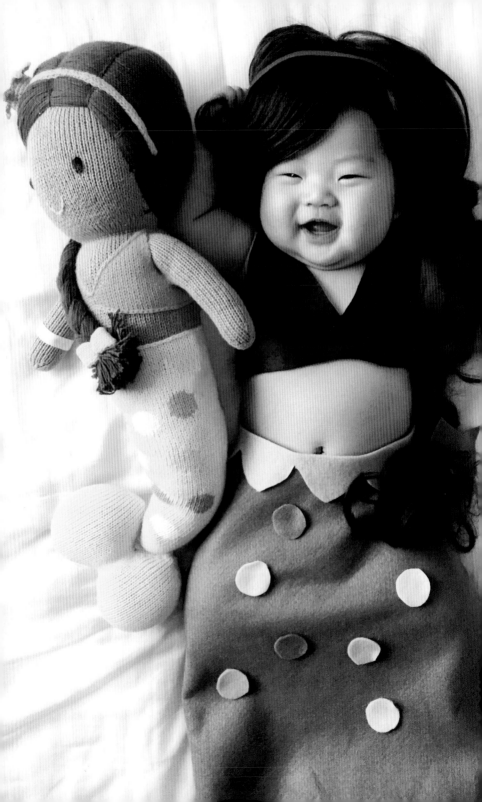

YOU USED TO CALL ME ON MY SHELLPHONE.

Mushy peas&
Pumpkin puree
Turkey cubes&
Givin' thanks.

WHY DID THEY
LET THE TURKEY
IN THE BAND?

CUZ HE HAD
THE
DRUMSTICKS.

A FRIEND ASKED IF I
WANTED TO GO SLEDDING.
I SAID THERE'S SNOW WAY.

GOKU WAS A BABE. I'M JUST SAIYAN.

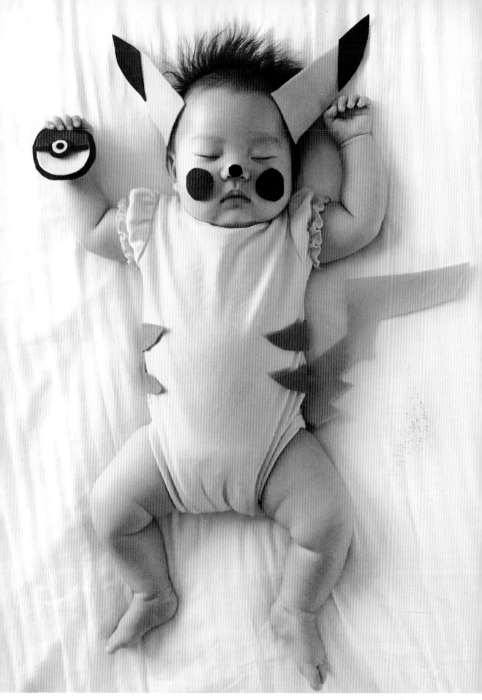

HEY BABY GIRL, LET ME
TAKE A PIK A CHU.

84

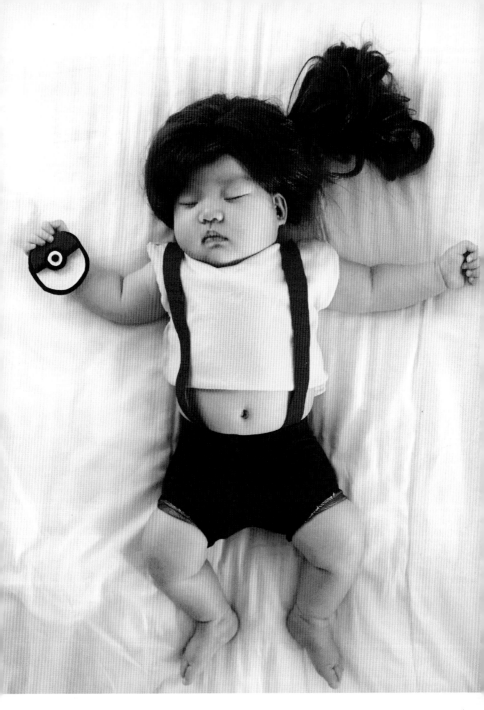

GOTTA CATCH SOME SLEEP.

85

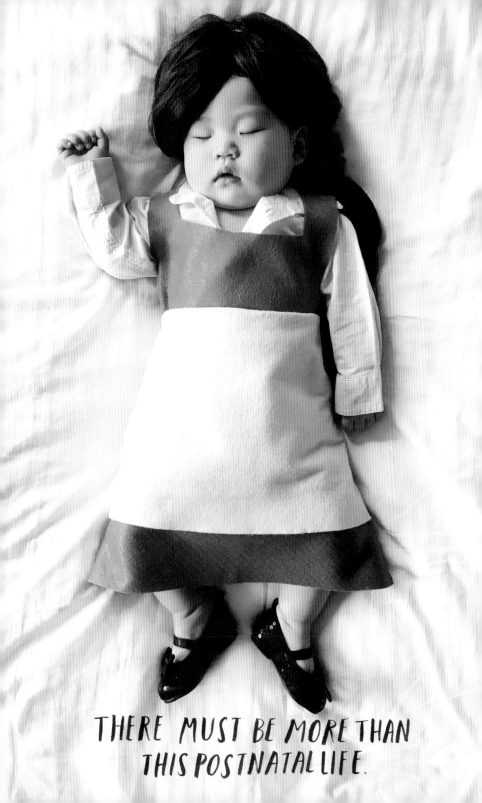

THERE MUST BE MORE THAN
THIS POSTNATAL LIFE.

BE AT REST! BE AT REST!

SNORES
AS OLD AS TIME,

SNOOZE
AS IT CAN BE.

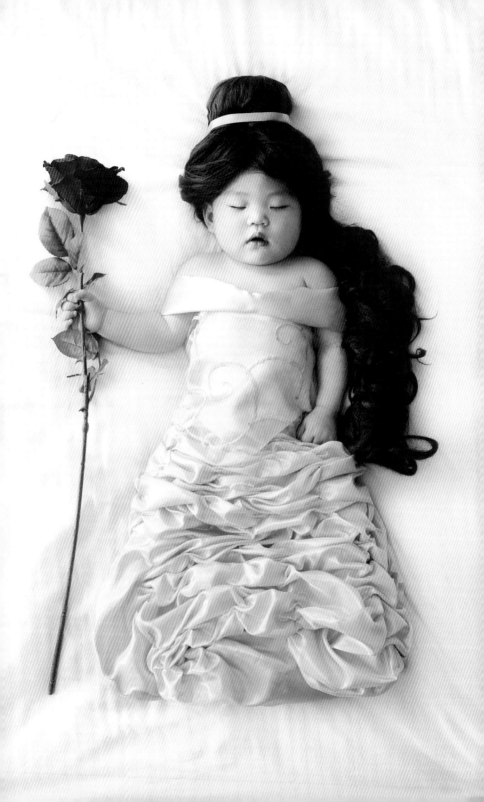

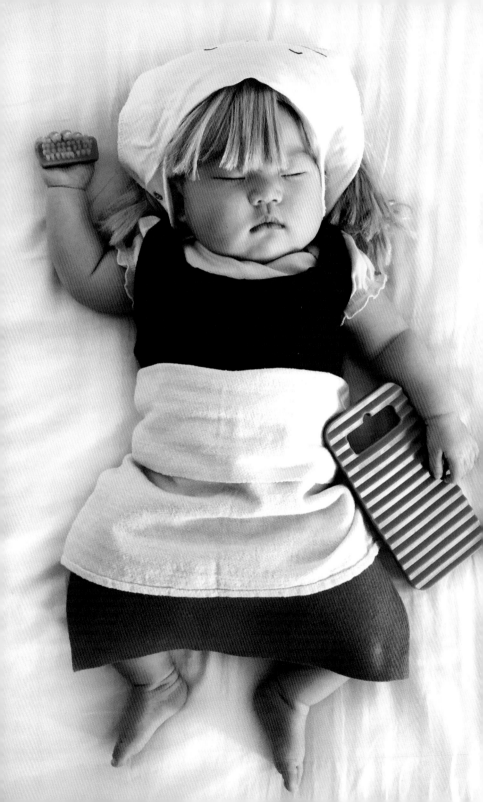

WHY CAN'T CINDERELLA PLAY SOCCER?

CUZ SHE KEEPS RUNNING AWAY FROM THE BALL.

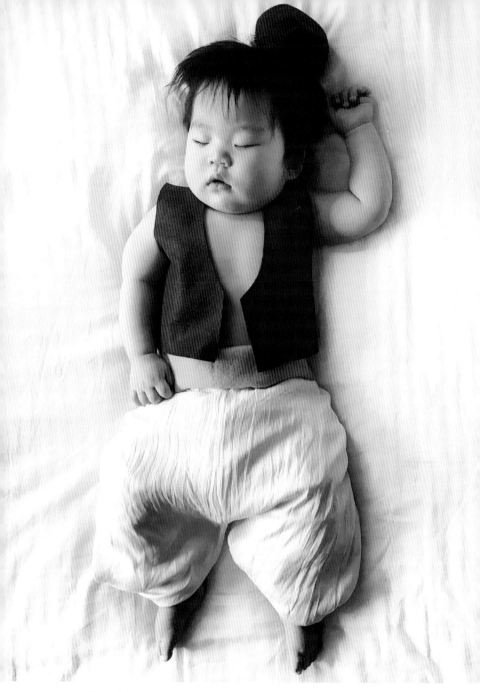

I CAN SHOW YOU THE WORLD...
JUST GIVE ME 5 MORE MINUTES.

WHY DID PRINCESS JASMINE GO TO THE
FRUIT STAND IN THE MARKETPLACE?
SHE WAS LOOKING FOR A DATE.

WHAT DID PAUL BUNYAN SAY WHEN
HE POOPED HIS PANTS?
IT WAS AN AX-IDENT.

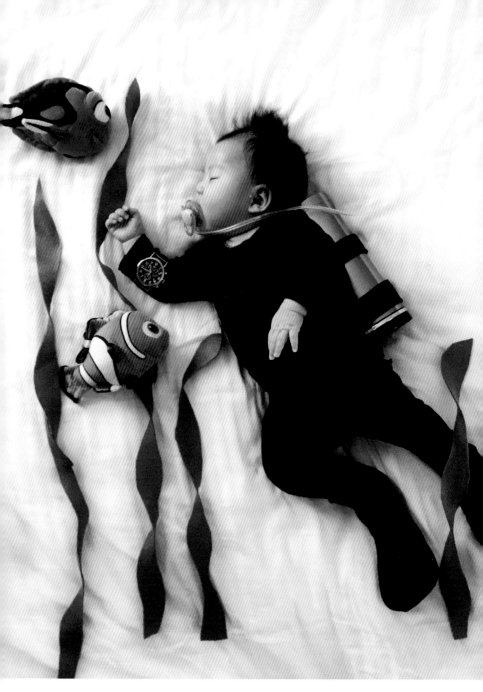

JUST KEEP SLEEPING.
JUST KEEP SLEEPING.

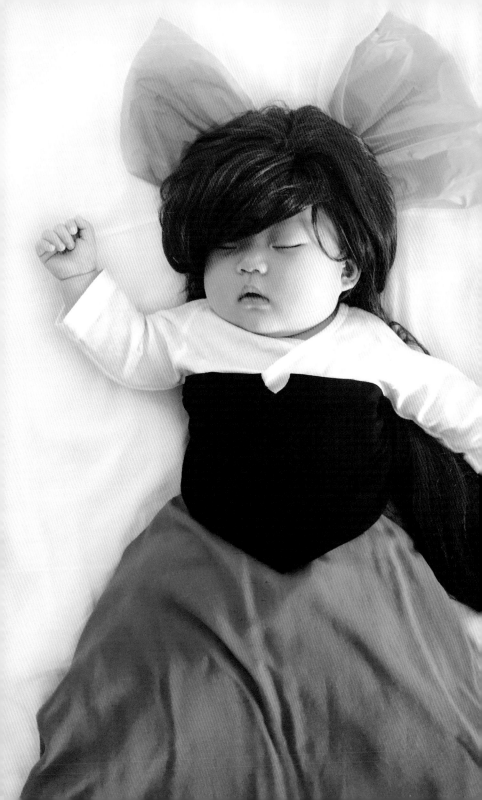

PRINCE ERIC?
I THINK WE
MERMAID
FOR
EACH OTHER.

FLIPPING YOUR FINS YOU DON'T GET TOO FAR... WHEN YOU'RE PASSED OUT.

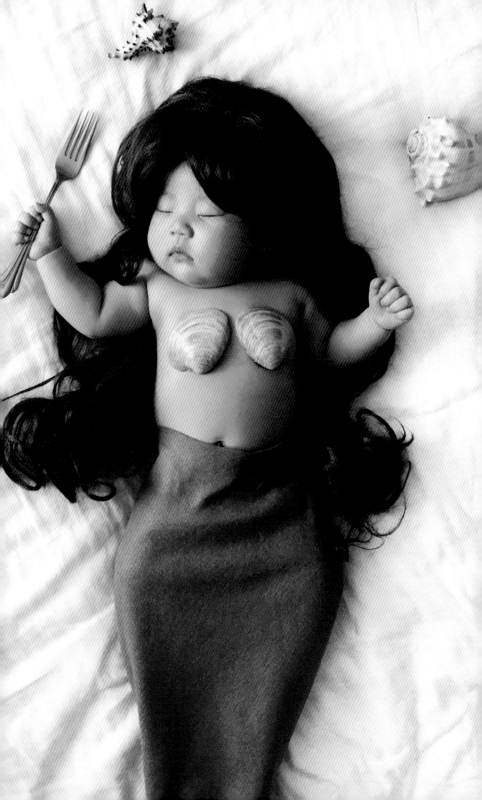

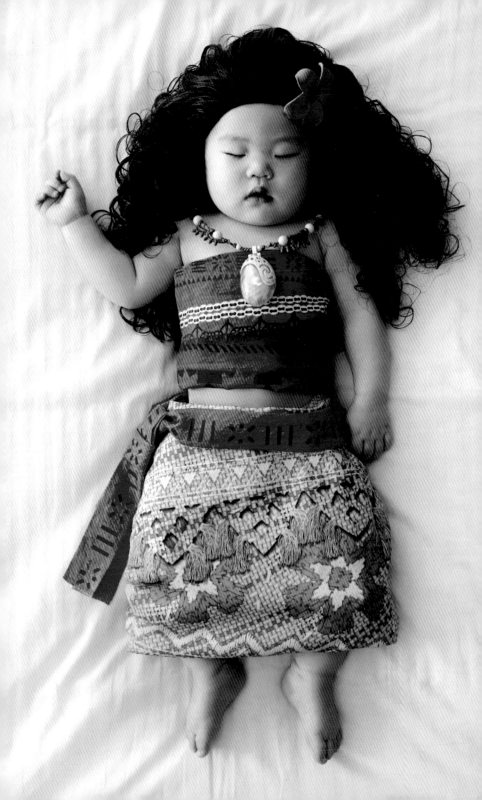

ONE DAY
I'LL KNOOOOW,
HOW FAR I'LL
SNOOOORE!

THAT EPISODE WHEN MARGE
HAD HER HAIR DOWN

#CHEERIOSCHALLENGE

NAP
SO
HARD

PLEASE DONUT WAKE ME UP.

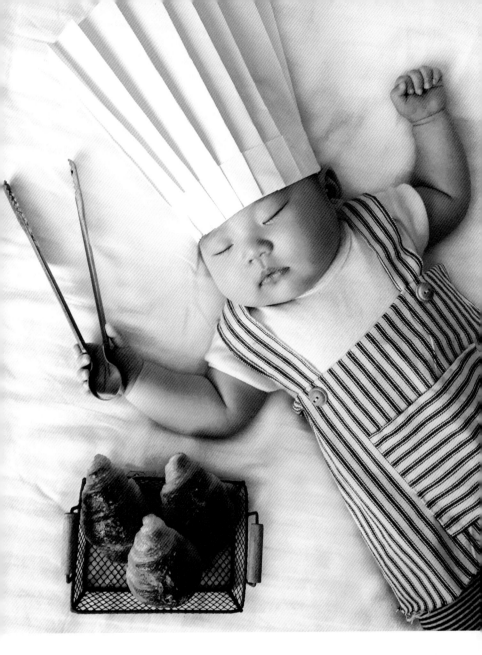

WHY WAS THE BAKER SLEEPING?
CUZ SHE MADE A BAKER'S DOZE-IN.

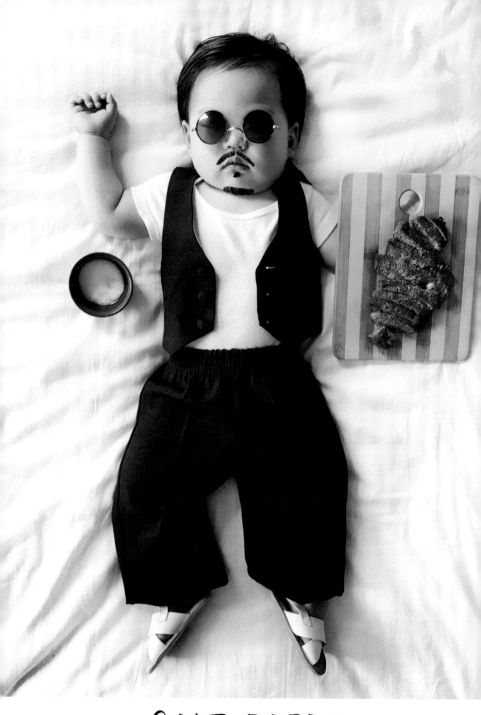

SALT BAEBY

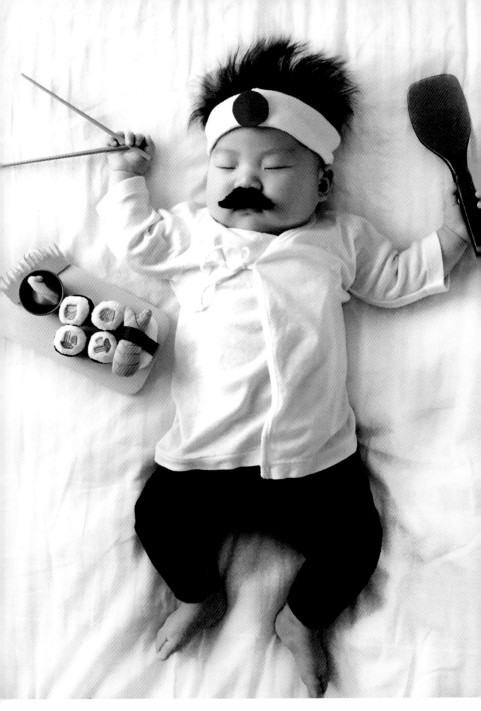

JOEY DREAMS OF SUSHI

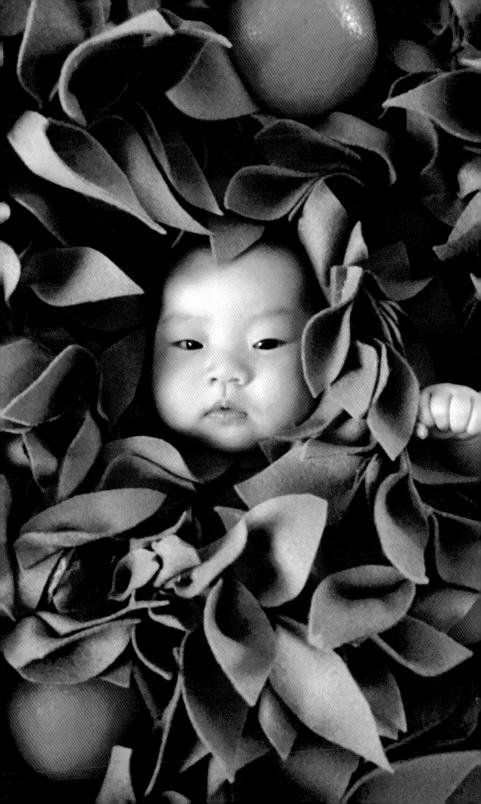

IT'S HARD TO CONCENTRATE
WHEN YOU'RE SLEEPY.

DID YOU HEAR ABOUT
THE ITALIAN CHEF
WHO DIED?

HE PASTA AWAY.
HERE TODAY, GONE TOMATO.

WE CANNOLI DO SO MUCH.

HIS LEGACY WILL
BECOME A PIZZA HISTORY.

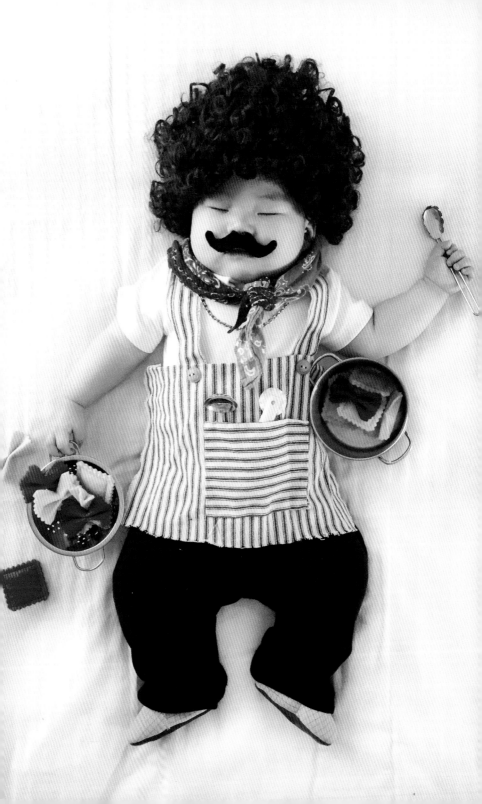

LET'S TACO 'BOUT IT
AFTER THIS NAP.

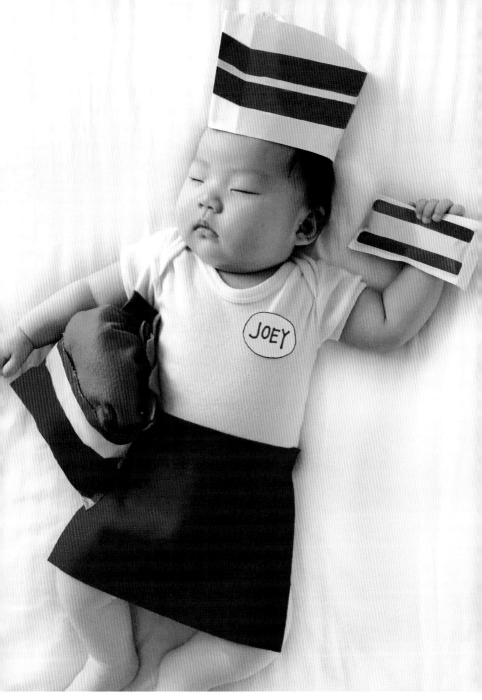

WHERE DO HAMBURGERS GO TO SLEEP?
ON A BED OF LETTUCE.

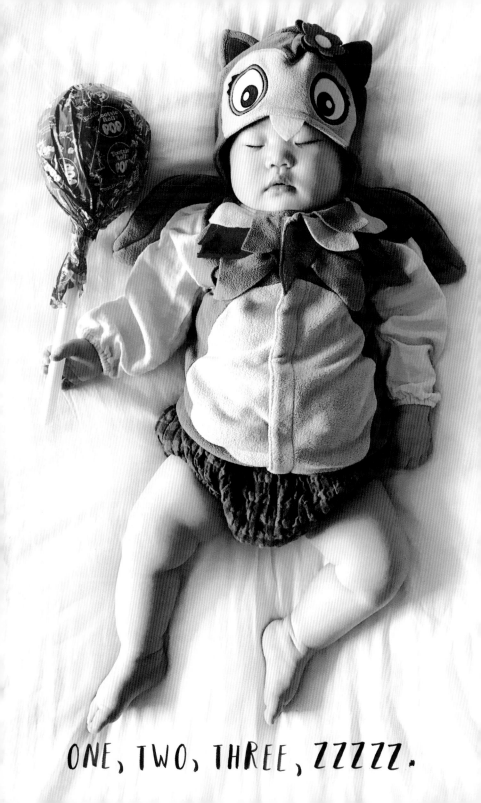

ONE, TWO, THREE, ZZZZZ.

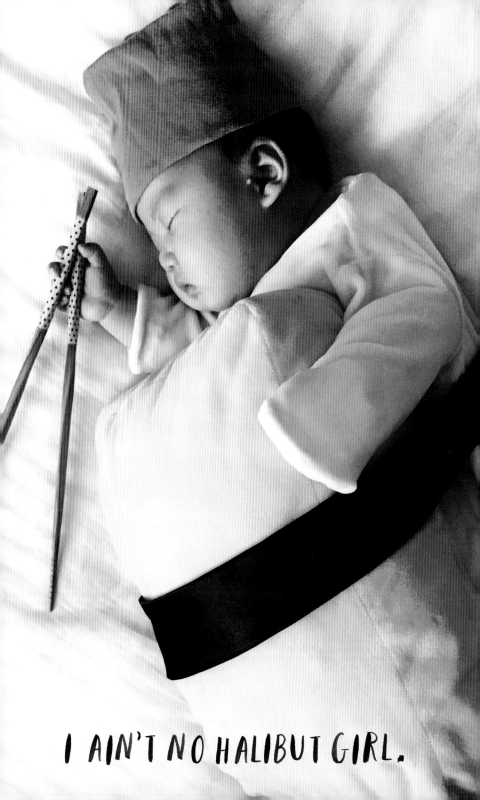

I AIN'T NO HALIBUT GIRL.

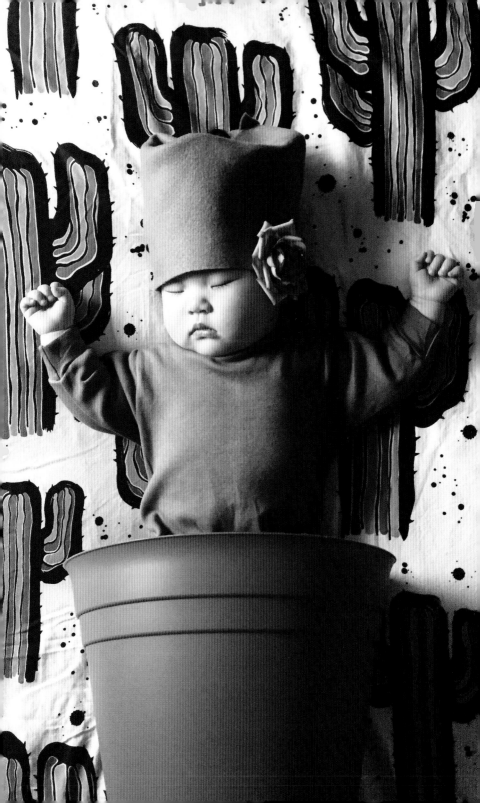

JOEY,
PRICKS WILL COME
AND GO, BUT I WILL
NEVER DESERT YOU.

THIS IS MY RESTING BEACH FACE.

CHURRO KNOW WHAT IT'S LIKE TO BE ME.

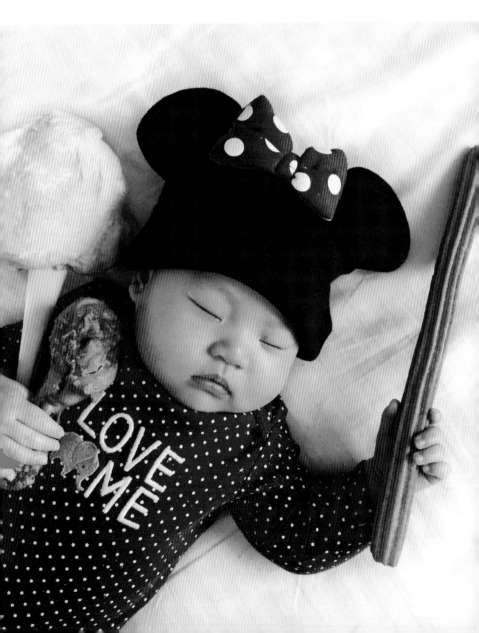

IN NEW YOOORK!!
CONCRETE JUNGLE
WHERE DREAMS
ARE MADE OF,
THERE'S NOWHERE
YOU CAN'T SNOOZE.

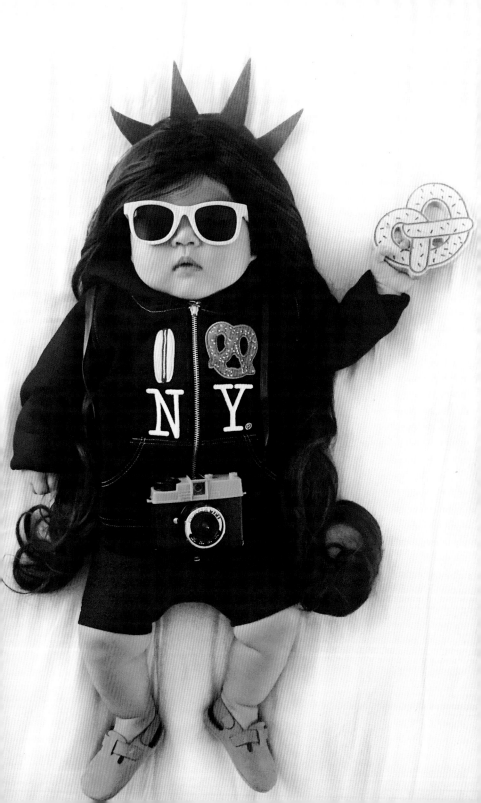

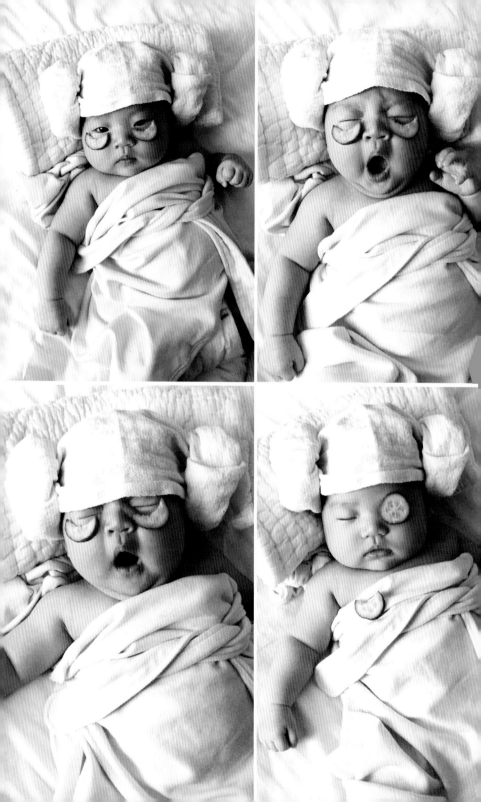

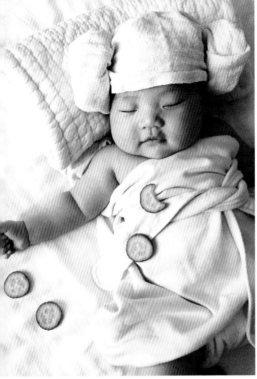

IT'S SPA DAY, **SPA DAY.** GOTTA GET DOWN ON SPA DAY.

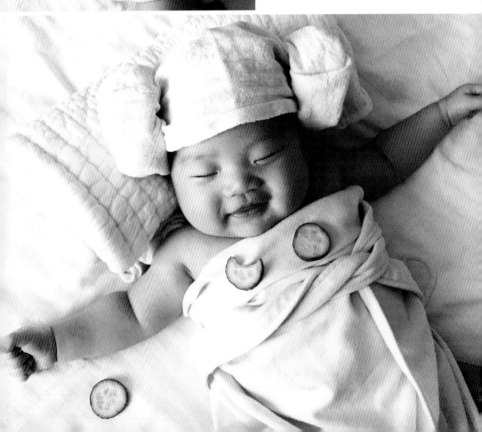

HERE TODAY,
GONE TO MAUI.